© Ryan Green 2014

Published by
Pineapple Music Productions
Ross-on-Wye
Herefordshire

First Edition

ISBN 978-1-291-70940-7

Music Theatre:

Concepts, Theories & Practices

Ryan Green

Falmouth University, UK

Contents 4

Acknowledgements 5

Bibliography 39

Acknowledgements

With thanks to the following Universities for the use of their libraries and their staff for their time and help.

University of Brighton
University of Birmingham
University of Exeter
Falmouth University
University of Gloucestershire
University of Nottingham
Nottingham Trent University
University of Plymouth
University of Sussex
University of Worcester

Also with thanks to:

Evelyn Ficarra BA (Hons.), MA, PhD
Lecturer in Music Theatre and Assistant Director of the Centre for Research in Opera and Music Theatre, School of Media, Film and Music, University of Sussex.

Joanne 'Bob' Whalley BA (Hons.), MA, PhD
Lecturer in Theatre, Academy of Music and Theatre Arts, Falmouth University.

Dedicated to *Mum.*

Introduction

This book explores music theatre writing and research since its conception in the 1960s. It will explore what music theatre is or isn't and will serve as a resource for me to draw upon whilst writing my own music theatre portfolio. I will be looking at different practices and practitioners such as Kagel and Cage as well as more contemporary practitioners and music theatre groups.

There are several ways to stylise music theatre: *Music-Theatre*, *music theatre*, *music/theatre*, and *music-theatre*. Although there is no correct or incorrect way to write this I believe that no higher precedence should be given to either music or theatre. Throughout this paper I will be using music theatre thus with the exception of the beginning of a sentence where I will use: 'Music Theatre'.

A previous version of this paper was originally submitted to Falmouth University toward my degree of BA (Hons.) Music.

Music Theatre: a history, a definition

'Music Theatre' as a term, emerged in the 1960s. It was created as a response to opera, calling for a medium, which is smaller scale and not as boldly dramatic as opera. Music Theatre was developed about the same time as rock musicals from America came about. Music Theatre is often confused by most people with Musical Theatre, which are often nicknamed 'musicals'. Musicals previous to this time tended to be more opera-like, using large orchestras and mixing popular music with more operatic styles. These included such shows as *A Gaiety Girl* (1893) one of the first 'hit' musicals. While musical theatre continues to be the most popular form of theatre entertainment music theatre attempts to move away from following popular culture and looks more towards being a 'high-art' medium, which is a lot more challenging and experimental than musical theatre. I personally don't agree with the class war within art and refuse to believe that music theatre and opera is sometimes classed thusly. I also think it to be unwise to attempt a comparison between music and musical theatre as they are two different art forms and should be respected as so. I am, however

going to concentrate on what I believe music theatre can or cannot accommodate.

Music Theatre has several ambiguous meanings however, working from a number of sources, I have tried to compose a solid description of the art.

Some artists believe that music theatre can be used as an umbrella term to describe any theatre driven by music such as opera, musicals, ballet, cabaret and some contemporary music. Although I consider this to be true to an extent, I believe that a better term for this would be 'theatre music'. I think that music theatre is a completely separate art form slightly more distant from these already well-established forms. From my reading I like to believe that music theatre is not a stylistically fixed form of theatre, rather as Dr Zachar Laskewicz writes: 'the application of musical thought to the elements of theatre. [...] Music Theatre does not necessarily have a continuous plot in order to make the scenic representation convincing since musical completeness can be conveyed with the residue of a plot' (Laskewicz, nd). Music Theatre makes use of not just music and 'theatre' but draws from

a number of mediums including film, radio and other audio-visual effects. It is theatre which is music driven and does not have to include music but 'breathe a musical energy' which comes from movements and the profession of musicians as performers. (Hübner, 2010: 73) When describing a music theatre work, production aspects come high on the list: music theatre tends to be small-scale theatrical work. (Music theatre, 2006) and 'Much music theatre is created for very specific, often idiosyncratic ensembles. […] the music that results is frequently written for unusual instrumentation or combinations. This is often a barrier to revivals or second performances.' (Devlin, 1992: 41)

> "Music theatre is a response against opera, it is smaller in scale and highly experimental." (Ficarra, 2013)

The premise of music theatre is to make all performers equal. There is no 'them and us' and there is no stage/pit divide as in Musical Theatre. Here, the actors are musicians and vice versa.

Performance Artists and/or Musicians

There is often a confusion or synonymic problem with the correct job title given to someone who performs in the theatre, particularly from the viewpoint of a musician. When looking at music theatre, especially, there is a very fine line (and sometimes none at all) between actor and musician, or 'performer'. This interesting subject came up very early in my research, when I read a paper entitled: *Entering the Stage: Musicians as Performers in Contemporary Music Theatre* (2010) by Falk Hübner. Hübner's paper spoke of the musician in contemporary music theatre and how their roles have been expanded throughout the twentieth century right up to the present day. The paper explained how a musician becomes a performance artist simply by being given, or having responsibility taken away from them. An example given was that if you give a musician movement or chorography they are no-longer *just* a musician, similarly, if you remove their instrument they are still a musician but now must act as a performance artist; this could not be done by a non-musician, as they will not have had the required training to perform convincingly. (Hübner, 2010) Hübner's *Thespian Play* (2009) emulates this. The performer is centre stage with a

microphone and is standing as if holding a saxophone. The player performs to a track recording observing the chorography and movement, breathing and playing techniques required as if thcy were playing a real saxophone. The piece is fascinating to watch and after a while it becomes believable, the audience see the performer in every detail, every breath and every little movement. Following on from this paper I decided to continue in this vein of research. I found a book edited by Jack Burnoff, which discussed the difference between music played live and music recorded and played back:

> 'In order to understand [...] music in all its fullness, to see the gesture, the movement of the different parts of the body which produces it. The fact that all music which is created or composed requires in addition a means of exteriorization if it is to be perceived by the listener.' (Burnoff (ed.), 1968: 22-23)

Music is perceived to sound different if we see the sound being produced, usually down to timbre, acoustics as well as the visual movement of the strings' bowing and

percussionists' movements, creating performance out of making music. 'The sound you hear is not the same as the sound one sees being produced' (Butor *in* Burnoff, (ed.): 107) Again linking to the previous article *Entering the Stage* (Hübner, 2010), that these musicians become theatre performers when placed in the context of a music theatre performance. 'Many of them [music theatre works] incorporate the performing musician in the stage action' (Butor *in* Burnoff (ed.), nd: 37)

> '[T]o hear music is to see if performed, on stage, with all the trappings. I listen to the records in the full knowledge that what I hear is something that never existed, that never could exist, as a 'performance', something happening in a single time and space; nevertheless, it is *now* happening, in a single time and space: it is thus a performance and I hear it as one [and] imagine the performers performing [...]. (Firth, 1996: 211)

Other examples of actor/musicians include Kagel's *Sonant* (1960), which transforms the playing of musical instruments into theatrical action and *Sur Scene* (1960) presenting musical performance within a quasi-theatrical context (Heile, 2006: 35). Contemporary musical theatre works such as *Once* (2011) completely blur the lines between musician and actor by creating spoken and named roles in the book allowing the musician to slip in and out of accompanying the vocalists and helping developing the story. This idea is very much routed in the development of the opera and musical based where all roles are separate. Actors would speak the text and the Greek chorus or ensemble/choir would sing the developing songs, the orchestra remain safely in the orchestra pit and the dancers would come on and perform a ballet between arias. Practitioners experimenting with theatre are helping to change these ideas and merge the lines between singer, dancer, musician and actor – creating the *Performance Artist*.

Relevance in the Quotidian

Whether we realise it or not, music theatre has some impact on our everyday lives, particularly at school. We, as children, are given instruments and a plot or short story and told to come up with a 'play' to show to our classmates. As children, we are less scared to experiment with these instruments and see what sounds we can make, especially if we have had no formal training. As adults, particularly musicians, we tend to become less experimental. Once we have had our formal training we know the correct way to hold or play our instruments and a wrong note is, well, just not allowed and there is something interesting to watch players' reactions when they do play a wrong note. We have a tantrum and try again usually slower, making sure we do not make the same mistake again. This pseudo-music theatre is replicated in music practice rooms all over the world. But what actual relevance does music theatre have on our everyday lives? Well, it depends on the context and how we see the art. For someone interested in music theatre, they might go and see a piece every week, should they live in an area where contemporary music theatre is easily accessed. I set myself a task to look around me and purposely look for music theatre and try

to answer this question; I found three main examples of contexts where we see music theatre on a day-to-day basis:

1. Theatre: In the theatre itself, we explore new works, or are dragged along by our friends or family.
2. Advertising: Using the contemporary to sell, as it seems exciting and new, obvious examples include selling cars or perfumes.
3. Street Arts: Street performers, musicians, magicians.

We are constantly being subjected to the term, which is wrongly used in most cases, where people mean music theatre to be an umbrella term as discussed previously, such as to include theatrical works that sit between music and opera almost 'musical operas,' a term I may have coined whilst writing my own musicals, and one I favour for such works as 'Les Misérables' or 'The Phantom of the Opera', music theatre (in the umbrella termed sense of the phrase) works which bridge the gap between a popular musical and an opera.

Several interesting theatre companies are currently keeping music theatre alive throughout the world; one in particular is *Punchdrunk*. *Punchdrunk* recently ran an immersive sound and music theatre piece at the *National Theatre* in London. The piece was inspired by Buchner's *Woyzeck*; this theatrical journey 'follows its protagonists along the precipice between illusion and reality' (Current Shows, 2013). *Punchdrunk*, since 2002, as a company have been working on a changing form of immersive theatre where audiences are allowed to roam freely throughout the 'piece' allowing a new world to be created without the limit of a proscenium arch or seating. Their pieces blur the lines between space, performer and spectator allowing audiences to re-discover their 'childlike excitement and anticipation of exploring the unknown and experience a real sense of adventure' (Company, 2013). The music used is very much a constant soundscape as the audience moves between the floors. The performers may suddenly break out into a dance when music is played and so on and so forth. Another company *Kneehigh* [Theatre] based in Cornwall began work in 1980 with Mike Shepherd at the helm. Their work can often be described as music theatre as it is often small-scale and music driven.

Kneehigh's music is often programmatic and tells a story without lyrics but still supporting the action on stage. *Kneehigh* tour all over the world exposing music theatre to thousands of people. Being an experimental theatre company *Kneehigh* sometimes blur the lines between writing in an experimental style to writing in a musical theatre style. (Green, 2012: 4) *Kneehigh* like *Goat Island* are a performance group, and rarely refer to their work as 'music theatre' despite all the indicating signals pointing towards the art form. It is interesting that this term is so widely disregarded, mainly because of the confusion with musical theatre.

Goat Island are an American company. They use text, but not to tell a standard theatrical narrative or story; and they use movement, though not what laymen may call 'dance'. They combine those texts and movements and create something beyond those individual components of text and movement, and the best word we have for that is 'performance'. (Goat Island, nd.)

Exploring Contemporary Music

A major part of music theatre is of course music. This is the area I am most interested in, not just in music theatre, but all types of theatre music supporting what is happening on the stage or in the 'space'. In this section I am going to talk about experimental, contemporary music in general but focusing upon the music of theatre. The music of music theatre theoretically cannot stand on its own without the supporting stagecraft, costumes and movement very much like ballet. Musical's and opera's music often stands up alone without the aforementioned and in order to better market a show a cast recording will be released either prior to opening or during the first month of previews, especially if the piece is a new work. There are always exceptions to this, *London Road* (2011), a verbatim music theatre work originally produced in London, released a cast recording which grabbed the attention of the theatre community as the work, although highly experimental was very listenable and felt almost like a musical with a strong story line and easy listening music. As music theatre pieces tend to be fairly short a cast album would sometimes cost more to produce than the producer would actually sell. Leaving cast recordings aside, several contemporary

musical theatre works are currently striving to be 'the latest' and most exciting shows to hit West End or Broadway theatres. Etc.

'Those You've Known Score' (Ed. Ryan Green)
(Sheik et al, 2006)

Spring Awakening a musical by Duncan Sheik took Broadway by storm in 2006. The musical set in provincial Germany sort to dramatically mix the concepts of music and musical theatre. By offering a very small production value with minimal staging and costumes the piece felt like a music theatre work until you heard the music. With a rock orchestration the actors pull microphones out of their costumes and sing as if to show the audience what is

happening in their heads. However, the thing about *Spring Awakening* that fascinates me as a musician is the orchestrations, the strings in particular. This experimental writing suits the musical perfectly by offering a rock drumbeat over some lush and highly detailed string writing. The finale of the musical – 'Those You've Known' demonstrates this perfectly. The rocking in the viola and 'cello emanates that of a mother rocking a baby, the drums lean towards the idea of strength backing the lyrics and almost re-enforcing the story, as a pseudo-reprise the song here re-enforces the character's aims and his willingness to prevail against all the set backs in life.

> "Now they'll walk on my arm though the distant night.
> And I won't let them stray from my heart." (Sheik,
> Slater, 2006)

London Road was a music theatre work created by Adam Cork and Alecky Blyth. The work is unique as it mixed music with the verbatim speaking technique. Blyth collected recordings from the residents of London Road in Ipswich after the Steven Wright Killings occurred. Together Blyth and Cork pieced several songs

together, using these recordings, and carefully ensured that every accent, stammer and inflection was reiterated in the score:

'Begonias and, petunias and, um, impatiens and things.'
(Blyth & Cork, 2006)

This technique was originally created by Anna Deavere which Blyth pioneered. Deavere was the first to combine the journalistic technique of interviewing with the method of interpreting their words through performance. (About, nd.)

'The technique involves recording interviews from real life and editing them into a desired structure. The edited recordings are played live to the actors through earphones during the rehearsal process, and on stage in performance. The actors listen to the audio and repeat what they hear. They copy not just the words but exactly the way in which they were first spoken. Every cough, stutter and hesitation is reproduced. The actors do not learn the lines at any point. By listening to the audio during performances the actors remain accurate

to the original recordings, rather than slipping into their own patterns of speech.' (About, nd.)

Cork's music surrounding this technique is not simple in itself. He uses complex rhythms, and often heavily contrapuntal lines of music to highlight subtext or complications. Without a copy of the score, it is difficult to pin-point exactly what is happening in each section of music. Cork tends to stick to one style of music, a bland one, which doesn't particularly overpower Blyth's writing. He briefly uses club-like music in 'It Could Be Him' where two young girls are having a conversation and again in 'They Like a Good Moan'. He writes in a style similar to Peter Maxwell Davies for 'We've All Stopped' a slightly awkward piano melody with strong power chords in the bass line. It is not clear who the orchestrator is, however the piece is orchestrated for woodwinds; guitars; keyboard and percussion.

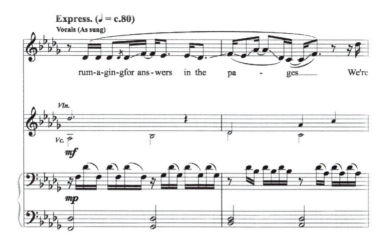

'Us', Reduced Score. (Spektor, 2006)

Regina Spektor is an American contemporary popular music artist known for songs such as 'Us' and 'How'. She has crafted a unique sound is experiments with vocal technique. The aforementioned song: 'Us' demonstrates her style perfectly. 'Us' is notable for its use of a string quartet, not commonly found in her other songs.

The base line is based on a re-iterated Db pedal under a heavily melismatic, almost portamento melody in some places. Specktor performs the piece with ease, changing the pronunciation and

inflections of words such as 'rummaging' where she pronounces it as 'rummagina' a mutation making it easier to sing: 'for answers'. Using these ideas I will be able to develop my own vocal writing with both melismatic and syllabic styles. I'm glad that I have looked into contemporary popular music as many ideas can be transferred in to music theatre work. Slurring, melisma, portamento and appoggiaturas can be used in a number of different ways to alter the sound of words to force or empahsie a rhyme or important lyric, supported by the accompaniment.

Practice and Practitioners

Here I have chosen several practitioners to illustrate the music theatre art further. An interesting point is that is most of the resources that I have found are written by composers not theatre practitioners.

Mauricio Kagel

Kagel was drawn to music theatre and is where he most left his mark. Most, if not all of Kagel's work has an element of theatre. Kagel revolutionised the standard Western music concert by offering a new music experience. He was malicious in his writing, from the music to the stage direction and costumes of the work. He choreographed how the performers entered and exited the performance space, the rules concerning applause and the curtain calls. (Heile, 2006: 33) Kagel, after Schoenberg and Stravinsky developed new ways of combining theatrical elements with musical ones, which helped develop a clear established division between opera and text delivery of song cycles. (ibid) Aleatory technique and graphic scores acknowledged the performer as an important collaborator in the creation of music performance.

'Performance is largely thought [of] as a means realizing [*sic*] a score.' (Heile, 2006: 33)

Kagel developed his new forms of music theatre based on pre-war Avant gardes, later followed by Stockhausen, Berio and Legeti. Kagel was heavily influenced by the Fluxus movement and John Cage. He attended many Fluxus events; he was not however influenced by 'happenings' although he was tempted by the anti-art movement. This is not reflected in his work as most works contain a rather crucial element of expression and artistic integrity. (Heile, 2006: 35)

Whist visiting University of Nottingham, I was able to access a copy of Kagel's 'Match' (1964). This music theatre piece depicts a tennis match between two violoncellos with a percussionist acting as an umpire. This piece is a perfect example of where the music of music theatre cannot survive without the rest of the work's aspects.

The performance space is laid out thus:

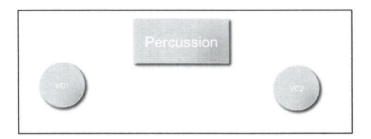

Kagel's score contains details of how the percussion should be laid out, making movement as efficient as possible for the performer. The score contains detailed instructions for all performers throughout but primarily at the beginning. Kagel often invented his own scoring systems, mixing them with traditional Western music notation. The work is heavily programmatic although the visuals make it a music theatre work. The piece beings with the obvious toing and froing of the ball played by the 'celli – marked as secco (dry) in the score played with a Bartok pizzicato, creating a percussive 'slap'. Later on the players are awarded points or reprimanded for foul play by the 'umpire' (percussionist). As Helie (2006, 53) writes, *Match* relies on humour to cover up the 'dreariness' of experimentation; the

score is listenable but cannot exist without the humour portrayed on stage.

Kagel's writing is precise and articulate. He uses Western standard notation alongside his own notation practices. The score requires a lot of skill and practise in order for a performer to master it, as well as constant vigilance with regard to dynamics and articulation.

I have made little reference to some obvious major music theatre composers throughout this essay including John Cage and Harrison Birtwistle, and although I do not dispute their impact on the art I have felt that there are several other practitioners who are more relevant to contemporary music theatre writing.

A company whom I have had some interaction with in the past are *The Fictional Dog Shelf Theatre Company*, founded by a previous lecturer of mine, Dr 'Bob' Whalley (Falmouth University) and her husband Dr Lee Miller (Plymouth University).

'Let them tell you the stories that have slipped between the cracks. The stories that sit abandoned on the hard shoulder, that hide in the shadows of multi-storey car-park, and the stories that get tanked up on duty free and disgrace themselves in toilets. The Fictional Dogshelf Theatre Company are pleased to have this opportunity to take you with them on a tour of all their favourite [*sic*] places. The places between A and B, the places that you would probably like to forget. As part of the New Work Network launch event at the 291 Gallery, Shoreditch, Dogshelf will present Commit to Memory, a durational performance which explores what happens when work made for a specific site is relocated to the context of the gallery space. From two large boxes, two performers unpack the material they need to map the spaces they have traversed, the spaces that have brought them here. As they unpack the material, the gallery becomes a palimpsest, a room of traces, echoing with the stories of other people, other places.' (The Original Press Release. (Whalley, 2013))

At the Practice as Research in Performance (PARIP) conference [University of Leeds] *Fictional Dog Shelf* performed Re-*Commit to Memory: In Which Bob and Lee Spent 12 Hours at a Loss*, which was a durational performance situated in a corridor. (Allegue et al, 230) It began with woodchip wallpaper laid across a long corridor very neatly and carefully. The paper was inscribed the paper with differently kinds of architectural non-places, such as shopping malls, airport lounges, motorway service stations, using charcoal. Rubbing them out and starting over and over again - creating a manuscript for the non-place in a constant state of 'erasure', and reinscription. The images were traced out then rubbed away, and sometimes literally scrapping away the previous marks to overlay new ones. (Whalley, 2013) Whilst this was happening, Miller and Whalley told their audience stories about these 'non-spaces'. They told of their journeys together and how they met. The audience was encouraged to sing 'Leaving on a Jet Plane' whilst Miller strapped a desk fan to his chest and 'taxied' down the wallpaper runway. Miller and Whalley didn't leave the space for the entire twelve hours and used plastic bottles to 'relieve' themselves (very much based on their PhD) where they collected bottles of urine from

the side of motorways. The audience brought they performers gifts of food and 'gossip', their own songs for us to sing with them. "They slept alongside us, listened to us, made their own marks on the paper. Lee made cakes to feed the stragglers and we tried to work out how psychic we were." (ibid.) Alongside this Miller and Whalley broadcast their work on a very local pirate radio station, which broadcast for the 12 hours, which their audience could tune into using cheap personal radios with headphones. This broadcast had other connected texts spoken by us, such as shipping forecasts for non-places, and advice for how the audience might make your way around these non-places. (ibid.)

It is remarkable how most of the practitioners that I have been researching are mainly academically focused. It seems that we rely on academic institutions to teach contemporary theatre work instead of it being a self-discovered art like musical theatre (there is probably a group performing musical theatre works in every town up and down the country).

Conclusion: The Future of Music Theatre

Music Theatre is a still developing art form and its future is not clear. As Devlin writes in his report, published 1992, he highlights several reasons why contemporary music theatre works are not often playing; these include the inevitable financial costs of running even a small cast/orchestra show. He writes that paying an orchestra for two rehearsals a zitzprobe [sic] and a dress rehearsal can come out at £3,000 at *Musicians' Union* rates (as of 1992). The return investment will barely cover costs, hence why it is important to run in a city where a more contemporary audience exist.

Devlin's (rather predictable) solution to this problem of exclusivity within the genre is education and marketing. He suggests that non-metropolitan audiences could be exposed to new forms both by established members of music theatre circles proactively reaching out to these new audiences by running community projects, and that existing local groups should come to see music theatre in its own natural, metropolitan habitat, and participate in workshops. This, he argues, would discredit the notion that music theatre is somehow inaccessible, intellectually

and socially exclusive, and inherently pretentious. In chapter seven, Devlin calls for more professional administrative support of opera and touring music theatre companies, pointing out that most run without a permanent structure, and are sustained mostly by the help of volunteers.

There are specialist universities across the United Kingdom offering courses in Contemporary Music Theatre, these include:

Falmouth University, Cornwall

'An emerging new art form, music theatre is full of innovators and Falmouth is on the frontline. Building on the Dartington College of Arts legacy. [...] BA (Hons) Music Theatre at Falmouth is for aspiring actors, performers, composers and makers who wish to explore the possibilities of new work that engages the intersections between music, sound and theatrical performance.' [Their] 'progressive, multidisciplinary course has an intensive practical focus, exploring music, theatre, writing, image, movement, design and technology in the shaping of brave new work. Alongside this, [students] examine the sonic, physical and visual elements of music theatre pieces and how they've been

created to help you work confidently with all of these forms, combining them in exciting new ways.' (Music Theatre (BA Hons), nd.)

University of Central Lancaster (UCLan), Lancashire

UCLan's BA(Hons) degree in Music Theatre gives students the opportunity to participate in all aspects of music theatre performance. The practice-based course offers you the chance to engage in music theatre practice through a combination of skills development, performing and devising work and investigation and research. Their Music Theatre course aims to provide students with the opportunity to perform in the production of existing works and also the creation and realisation of new work. You will participate in one major production in each year with an opportunity to create a major devised piece in both second and third year. (Music Theatre, nd.)

University of Sussex, Sussex

Sussex's *Centre for Research in Opera and Music Theatre* (*CROMT*) is an international centre for research and development in the practice and theory of opera, music theatre

and other related forms of sonic and multimedia performance. The Centre promotes innovative artistic and critical practices across a range of forms through academic programmes, creative, theoretical and historical research projects, and research collaborations with relevant professional and educational partners. (About, Nd.)

CROMT aims in particular to further knowledge and understanding of recent and contemporary practice in opera and music theatre, and of other global forms of music theatre, and to bring current modes of critical and theoretical understanding to works of the past. The Centre recognises an expanded field of contemporary practices that might include, e.g., live art with sound, digital performance, multi-media installation, sonic art, site-specific work or community projects as well as more conventional theatre-based work. (ibid)

Sussex also offers MPhil and PhD courses in Music Theatre.

This is exciting for the future development of music theatre by fostering a younger, fresh generation of composers, devisers and

theatre artists. As for the development of music theatre outside of these institutions especially in Europe we rely on practitioners such as *Punchdrunk*, *Kneehigh* and *Hübner* to continue writing new music theatre, but it really is down to education that music theatre will continue to be developed and become an internationally recognised art form.

Bibliography

Written Sources

ALLEGUE, L., JONES, S., KERSHAW, B. and PICCINI, A. 2009. *Practice-as-Research*: *In Performance and Screen*. London: Palgrave Macmillan.

BORNOFF, J. (Ed). 1968. *Music Theatre in a Changing Society*. Paris, United Nations Educational, Scientific and Cultural Organization.

BLYTHE, Alecky and CORK, A. 2011. *London Road*. London: Nick Hern Books.

DEVLIN, G. 1992. *Beggar's Opera*: *A Discussion Document on Small-Scale Touring Opera and Music-Theatre in the U.K.* Calouste Gulbenkian Foundation. London: The Foundation.

FICARRA, E. 2013. Interviewed by Ryan Green [IN PERSON]. Interview with Evelyn Ficarra BA (Hons.), MA, PhD. University of Sussex, Thursday 10th October 2013.

FIRTH, S. 1998. *Performing Rites: On the Value of Popular Music*. Oxford; Oxford University Press.

GREEN, R. 2012. *Practice and Practitioners 2*. University College Falmouth incorporating Dartington College of Arts. Unpublished Manuscript.

HEILE, B. 2006. *Music of Mauricio Kagel*. Aldershot, England; Burlington, VT: Ashgate.

HÜBNER, F. 2010. *Entering the Stage: Musicians as Performers in Contemporary Music Theatre*. New Sound Magazine, 36, II, 63 – 73.

KAGEL, M. 1967. *Match: Für drei Spieler (2 Violoncelli, 1 Schlagzeuger)*. [MUSIC SCORE] London.

SHEIK, D, SATER, S, 2006. *Spring Awakening: Those You've Known*. (Adapted by Ryan Green) [MUSIC SCORE]. New York, Music Theatre International.

SPEKTOR, R. 2006. *Us*. (Adapted by Ryan Green) [MUSIC SCORE]. London, EMI Music Publishing.

ZAVROS, D. 2008. *Music-theatre as music: A practical exploration of composing theatrical material based on a music-centric conceptualisation of myth*. PhD. University of Leeds.

Online Sources

About the Centre: Centre for Research in Opera and Music Theatre (CROMT): University of Sussex. 2014. [ONLINE] Available at: http://www.sussex.ac.uk/cromt/about. [Accessed 24 September 2013].

Alecky Blythe - Recorded Delivery - About. 2014. Alecky Blythe - Recorded Delivery - About. [ONLINE] Available at: http://www.recordeddelivery.net/about.html. [Accessed: 24 October 2013].

Falmouth University. 2013. *Music Theatre BA(Hons)*. [ONLINE] Available at: http://www.falmouth.ac.uk/musictheatre [Accessed: 22 Oct 2013].

Goat Island. 2013. *Writing: Letter to a Young Practitioner.* [ONLINE] Available at: http://www.goatislandperformance.org/writing_L2YP.htm. [Accessed 21 October 13].

LASKEWICZ, Z. 1992. *The History and the Relevance of the new Music-Theatre.* [ONLINE] Available at: http://www.nachtschimmen.eu/zachar/writer/9201_HRM.htm. [Accessed: 21 October 2013]

Punchdrunk. N.d. *Current Shows.* [ONLINE] Available at: http://punchdrunk.com/current-shows. [Accessed 21 October 2013]

Shamir, B. 2013. *Courses.* [ONLINE] Available at: http://www.uclan.ac.uk/courses/ba_hons_music_theatre.php [Accessed: 22 Oct 2013].

Email Sources

WHALLEY, J., Joanne.Whalley@falmouth.ac.uk 2013. *Fictional Dog Shelf.* [EMAIL] Message to Green, R. (rg139749@falmouth.ac.uk). Sent 30 October 2013.

Notes

Made in the USA
San Bernardino, CA
23 June 2014